printing

graphicIDEA resource

printing

Building Great Graphic Design through Printing Techniques

First published in the United States of America by
Rockport Publishers, Inc.
33 Commercial Street
Gloucester, Massachusetts 01930-5089
Telephone: (978) 282-9590
Facsimile: (978) 283-2742

Distributed to the book trade and art trade in the United States by
North Light Books, an imprint of
F & W Publications
1507 Dana Avenue
Cincinnati, Ohio 45207
Telephone: (800) 289-0963

Other distribution by
Rockport Publishers, Inc.
Gloucester, Massachusetts 01930-5089

ISBN 1-56496-601-1

10 9 8 7 6 5 4 3 2 1

Design: Stoltze Design
Cover Image: Jonathan Linder
Back Cover: Top, left to right
Marche Aux Fleurs poster by Michael Quarez (See page 84)
Evah Magazine by Issen Okamoto Graphic Design Co., Ltd. (See page 53)
Getty Research Institute poster by The Offices of Anne Burdick (See page 62)

Bottom: *Émigré* Magazine by The Offices of Anne Burdick (See page 34)

Printed in China

Constance Sidles

This book is dedicated to my family, who have always encouraged my creativity even at the expense of missed meals and dust bunnies the size of Godzilla. They are truly the source of my inspiration.

printing

Years ago, when I was production manager for *Adventure Travel* Magazine, I went on a press tour at a large web printer in the Northwest. The sales rep was bragging, as reps are wont to do, about all the amenities his company could offer. "We're especially proud of our own personal ink chemist right here on staff," he said. "He can handle any kind of ink problems you get. He can mix any kind of ink colors you need. He is a magician!"

Since chemistry was literally a closed book to me in high school, I resolved never to have anything to do with this expert. But the sales rep looked so deflated when I told him to skip the chemistry lesson that, against my better judgment, I agreed to go.

We proceeded reverently to the great man's inner sanctum, deep in the bowels of the old building. The closer we got, the darker and more musty everything became. Modern steel struts and concrete floors gave way to twisty wooden beams and cracked stairs. Clouds of dust spurted at every step. In the darkest corner of the dungeon sat a wizened gremlin of a man, bent over a thick volume of Beilstein's Sacred Text of Chemical Knowledge. "This is Bob, our ink chemist," said my guide.

More like alchemist, I thought. Bob looked up and glared. Clearly he disliked being disturbed. Smiling weakly, I backed out of the room.

For years after that, my reaction to any mention of ink was to smile weakly and start backing up.

As a production manager, I knew that my whole job consisted of putting ink on paper, but I always focused on the paper part. Then one day, I realized that I didn't have to become a chemist to understand ink. In fact, I didn't really have to understand ink in the chemical sense at all. What I had to do was understand the characteristics of ink as they affected my designers' work. If I could do that, I could guarantee that their designs would print in the ways that they expected. In other words, I needed to know how ink behaves on press and what it can—and cannot—do.

Thus, you will never see a diagram in this book showing RGB arrows descending through a parallelogram of CMYK colors and emerging to hit the disembodied eye of the all-powerful Production Manager.

What you will find, instead, is a compendium of tips and tricks that should help you put ink in its proper place: on paper, where it belongs.

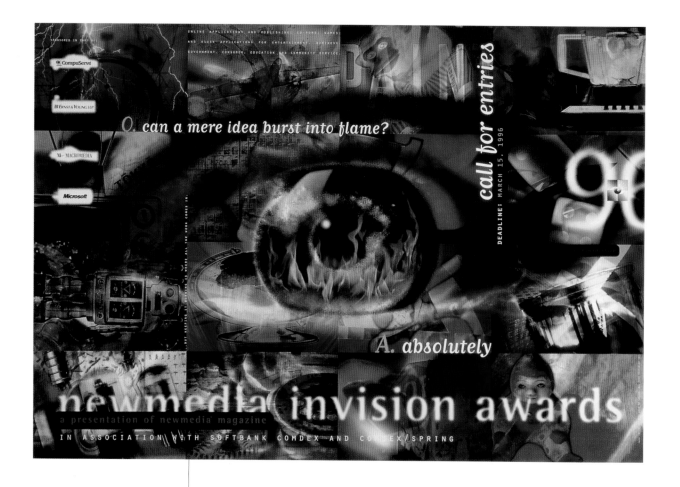

DENSE INK COVERAGE

Client	*New Media Magazine*
Design	*Cronan Design*
Art Director	*Michael Cronan*
Designer	*Anthony Yell*

If your design calls for dense ink coverage on an offset press, as did this one, select a paper with enough quality and weight to help the ink set up on the surface of the page. SWOP (specifications for web offset publications) standards specify that total ink density should not exceed three hundred percent, with only one color a solid. That standard applies to high-quality coated papers. Lower-grade papers simply plug up when ink densities get too high, making the image look muddy.

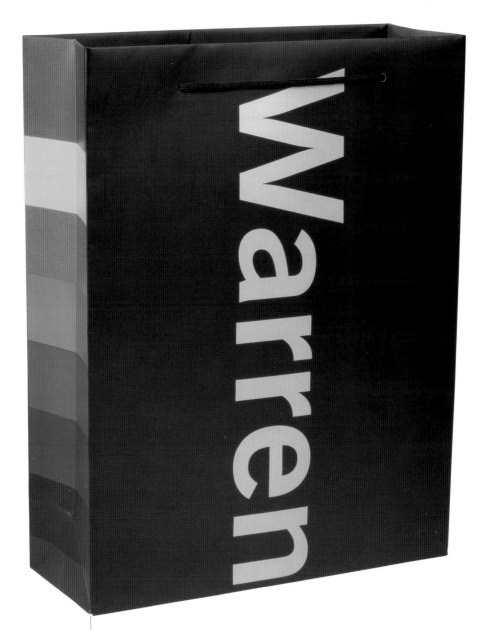

BRIGHTNESS

Client	*S. D. Warren Paper*
Design	*Siegel & Gale*
Art Director	*Jason Glassner*

In offset printing, you'll get the brightest ink colors on the brightest paper. Paper brightness is a measure of how much blue light a paper reflects. Since the colors we see are a result of white light passing through transparent ink films, striking the paper, and reflecting back through the ink film to our eyes, the more light a paper reflects, the more light will reach the viewer's eyes. Here, the paper is Warren Lustro Gloss Cover, a very bright paper indeed.

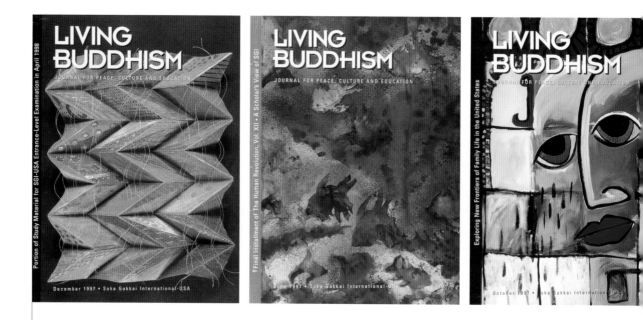

INK HOLDOUT

Client	*SGI-USA, Living Buddhism*
Art Director	*Gary Murie, SGI-USA*
Editor	*Margie Hall, SGI-USA*
Original Paintings	Mardi Gras *by Joyce Martin;*
(left to right)	Reef Dancers *by Tary Socha;*
	Honor Your Tears *by Donna Estabrooks*

Ink holdout refers to a paper's ability to let ink dry on the surface without sinking into the paper fibers. Papers with good ink holdout preserve detail because there's less dot gain. Colors look brighter because the ink reflects light back to the eye at a more uniform angle, instead of scattering light in all directions.

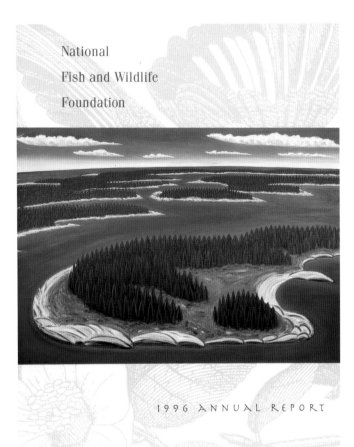

National
Fish and Wildlife
Foundation

1996 ANNUAL REPORT

HEAVY COLOR SATURATION

Client	*National Fish and Wildlife Foundation*
Design	*Feld Design*
Designer	*Annemarie Feld*
Photo Editor	*Susan P. Bournique*
Editors	*Jenny Pihonak, Sadhya Hall,*
	National Fish and Wildlife Foundation
Original Painting	Granite Passage *by William Farley*

Paper with the best ink holdout of all is heavily coated,
very bright, smooth, and glossy. Such papers can be
extremely expensive, but sometimes they are worth it.
Designs requiring heavy ink coverage, full color saturation,
and fine detail will plug up on cheaper paper. Take a
look at this cover, printed on Champion International
Krome Kote. The browns and indigos of the painting are
so dense they would turn to mud on any lesser paper.

Regional Director David A. Lehrer, Los Angeles
Mayor Richard Riordan, Multi-cultural Collaborative

VIGILANCE AGAINST INTOLERANCE

"*Every instance of hate or bigotry is one too many. We must continue our **vigilance against** all forms of **intolerance**, and we must speak loudly as a community when we witness injustice. This report indicates that ADL and concerned Angelenos are making a real difference in this important battle.*"

— Richard J. Riordan, Mayor of Los Angeles, speaking about the Audit of Anti-Semitic Incidents

AUDIT OF ANTI-SEMITIC INCIDENTS

Regional Director David A. Lehrer, Los Angeles Mayor Richard Riordan, Multi-cultural Collaborative Director for Hate, Regional Board President George E. Moss at the press conference announcing the findings of the 1996 Audit.

Since 1979, ADL has recorded and tracked reported incidents of anti-Semitic vandalism as well as assaults, threats and harassments directed against Jews or Jewish institutions. This information is an important resource for public officials and law enforcement agencies and underscores the necessity of ADL's unique work.

For the second straight year, the number of anti-Semitic incidents occurring in the United States declined. In 1996, the total number of incidents reported to the ADL was 1720. This total represented a decrease of 123 incidents or 7%, from the 1995 total of 1843. In 1995 the total, in turn, represented an 11% decline from 1994. This two-year drop was the first multi-year decline in ten years.

California ranked third in the nation in the number of reported incidents (186) behind New York and New Jersey. There were 128 reported incidents of assaults, threats and harassment against Jews or Jewish institutions — down 27% from 1995. Incidents of vandalism also decreased state-wide in 1996 - 58 incidents were reported, down 35% from 1995. The total number of reported incidents in Los Angeles County reflected the downward trend — 62 reported incidents in 1996, down 49% from 1995. Noting the decline, ADL Regional Director David A. Lehrer said "It tells us that the combination of community concern, law enforcement action and educational outreach is an effective approach that is reaping results in the traditional arenas where anti-Semites are active."

Flyer sent to a home in Los Angeles.

HATE CRIMES TRAINING

In an effort to increase the law enforcement community's knowledge and awareness of extremist group activity, as well as to assist them in recognizing and investigating bias-motivated crimes, the ADL has conducted extensive hate crime training seminars. The ideology and activities of

Report distributed at hate crime training seminars.

national extremist groups such as the Ku Klux Klan, neo-Nazi Skinheads, armed militias, and Christian Identity groups are examined, as well as hate group activity on the Internet. In addition, the seminars address various factors for identifying and defining a hate crime, constitutional issues in hate crime enforcement, and the residual effect of hate crimes on communities. Over the past year, law enforcement agencies in Los Angeles, Riverside and Ventura Counties and Las Vegas have participated in such seminars.

ADL ATTACKED IN DAILY BRUIN

This past spring, UCLA's student newspaper, the *Daily Bruin*, printed an anonymous attack on the Anti-Defamation League that consisted of unsubstantiated accusations and gross distortions. Entitled "Anti-Defamation League Infringes on Civil Liberties," the writer of the piece was permitted by the *Bruin* to shield his/her identity "due to possible repercussions." As a result, the paper seemed to be signaling its tacit approval of the writer's position and his/her fear of reprisal. Recognizing the error of its ways, the *Bruin* ran an unprecedented apology. "Principles of fear," it editorialized, "require those who make specific accusations against a particular individual or organization to stand behind those accusations, and not hide behind a cloak of anonymity. Moreover, anonymity deprives readers of information necessary to determine if the allegations made are credible." In addition to its apology, the newspaper also published an article by the ADL refuting the charges and detailing the League's demonstrated record of support for civil rights and liberties.

ADL response to attack in the Daily Bruin.

CSUN GIVES PLATFORM TO DAVID DUKE

One of the nation's most prominent racists, David Duke, accepted an invitation to debate the issue of affirmative action at California State University, Northridge. The invitation coincided with the debate over California's controversial anti-quota measure, Proposition 209. A former "Grand Dragon" of the Knights of the Ku Klux Klan, Duke was also the founder of the self-styled "National Association for the Advancement of White People." Attempting to soften his racist

ADL ad in The Sundial.

POROUS PAPERS

Client *Anti-Defamation League, Pacific Southwest Region*
Design *Kimberly Baer Design Associates*
Designer *Helen Duval*
Editor *Cheryl Azar*

Photos printed on paper without good ink holdout
look fuzzy and grayish for two reasons. First, the ink
sinks into the paper fibers, spreading out physically
and losing precision. Second, the paper scatters light
randomly as it reflects back through the ink film, so
there's less detail and color information. In this case,
the difficult nature of the photos, some of which
depict offensive acts, suggested to the designer a
treatment that would soften the horror.

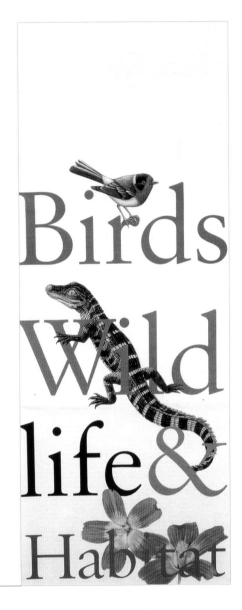

SMOOTH, UNCOATED PAPER

Client *National Audubon Society*
Design *Pentagram Design*
Partner *Woody Pirtle*
Creative Director *Woody Pirtle*
Associate/Designer *John Klotnia*
Designer *Ivette Montes de Oca*
Editor *Michael Robbins, National Audubon Society*

Although papers with the best ink holdout are usually
coated, there are some uncoated papers that are almost
as smooth and have nearly equal ink holdout. One such
paper is Mohawk Vellum, shown here. Look at how bright
the colors are and how much detail there is. When you
need bright ink colors but soft surface texture, consider
papers in this group.

COARSE SCREEN VALUES

Client | *The Radiological Society of North America Research & Education Fund*
Design | *Asylum*
Art Director | *Bill Current*
Designer | *Jen Baker*
Illustrator | *Pascal Milelli*

You can compensate for the dot gain you'll get on
uncoated paper by screening art at fewer lines per
inch: nearer 133 or 120 instead of 150 or more. You
may lose a little detail, but you'll also prevent inks
from plugging up on press and making designs look
muddy. The halftones in these designs do not require
pinpoint detail to carry the image; they do require
that the press maintain a clean, crisp look.

CONTINUITY OF COLOR

Client | *Lunar Design*
Design | *Michael Mabry Design*
Art Director/
Designer | *Michael Mabry*
Photographer | *Rick English*
Design | *Post Tool Design*
Designer | *David Karam*

Process ink changes color on different colors of paper. If continuity is important in a design, make sure the paper supply is guaranteed for the length of the campaign. In this example, Lunar sends oversized postcards to clients to maintain awareness and build relationships. Since continuity is a key to this campaign, inks must look like they belong to the same family from card to card.

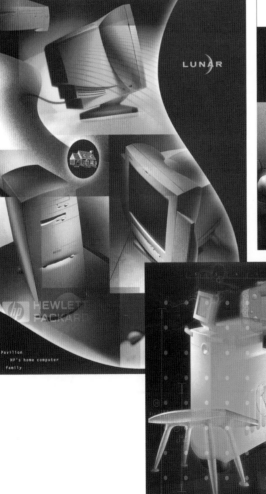

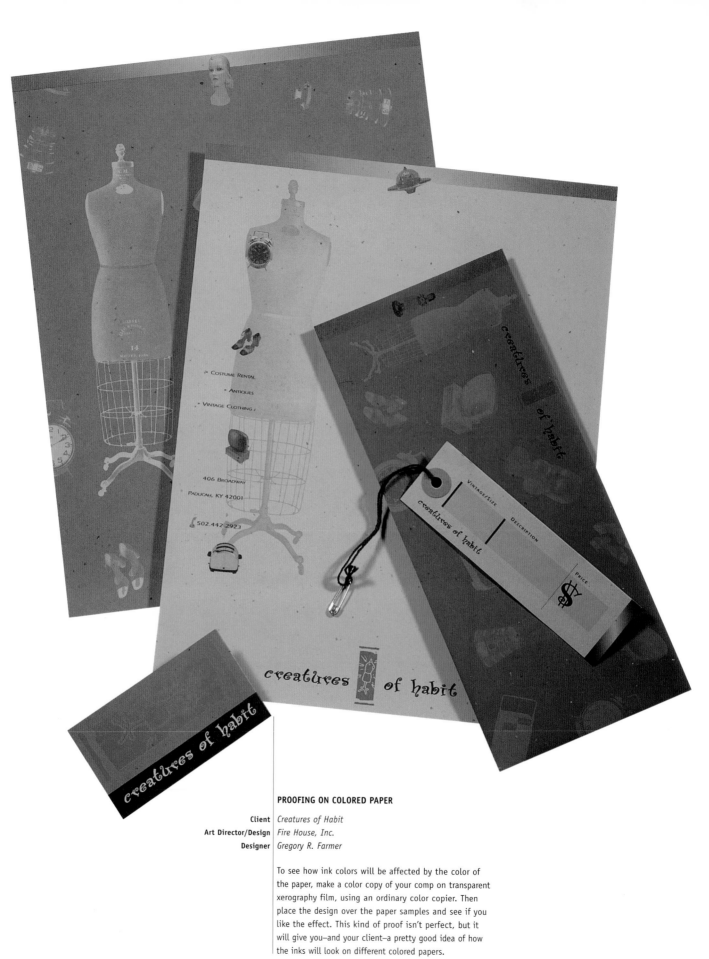

PROOFING ON COLORED PAPER

Client	*Creatures of Habit*
Art Director/Design	*Fire House, Inc.*
Designer	*Gregory R. Farmer*

To see how ink colors will be affected by the color of the paper, make a color copy of your comp on transparent xerography film, using an ordinary color copier. Then place the design over the paper samples and see if you like the effect. This kind of proof isn't perfect, but it will give you—and your client—a pretty good idea of how the inks will look on different colored papers.

PAPER COLOR AFFECTING INK COLOR

Client/Design | Canary Studios
Art Directors/
Designers | Carrie English, Ken Roberts
Illustrator | Carrie English

Here is a good example of how offset inks change color
on colored paper. Even when printed at one hundred
percent, the black ink allows the paper color to show
through, causing the black to take on the color cast of
the paper. This is not necessarily a bad thing—here the
effect actually enhances the design. Ink limitations only
become a problem when you don't plan for them in your
designs. In other words, I hate surprises. Don't you?

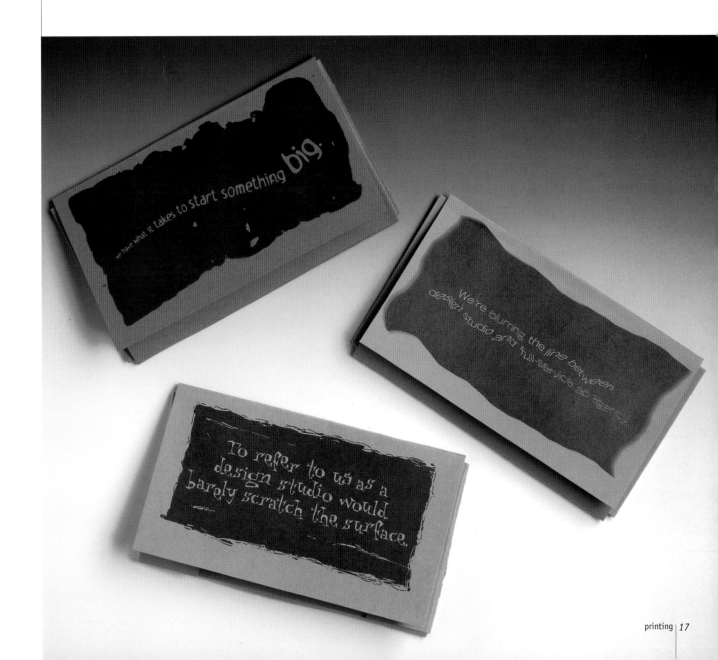

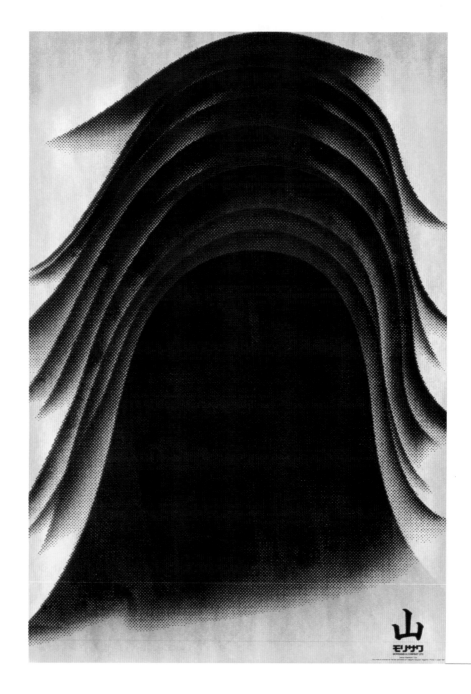

OPAQUE WHITE INK

Client/Design *Pentagram*
Partner/Designer *John McConnell*

Printing with process inks on dark paper, especially
black paper, is tough. Process inks are transparent, so
the paper color shows through, changing the hue of
the inks. To make process inks stand out on colored
paper, print a coat of opaque white ink off-line first,
let it dry, and then overprint with process inks—if you
trust the printer's registration skills.

INK DRAWDOWN

Client *Morisawa Typesetting Co.*
Design *Toda Office*
Designer *Seiju Toda*

In this example, the dark-blue and purple inks on brown
paper look almost black. One way to be sure of exactly
how inks are going to look on a given paper is to ask
your printer for an ink drawdown. He will put a smear
of ink from thick to thin on your paper so you can see
how solids and screens will appear.

SILK-SCREENED WHITE

Client | *Schertler Audio Transducers*
Design | *Sagmeister, Inc.*
Art Director | *Stefan Sagmeister*
Designers | *Stefan Sagmeister, Eric Zim*
Illustrator | *Eric Zim*
Photographer | *Tom Schierlitz*

Another solution for printing solid inks on colored paper is to choose a printing process that uses opaque ink, such as silkscreening. Here, the designer silkscreened a dense, solid white on brown chipboard, creating a surprisingly elegant effect. Notice there is no paper show-through at all.

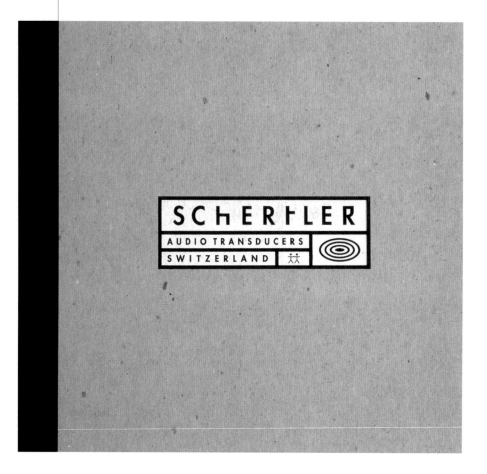

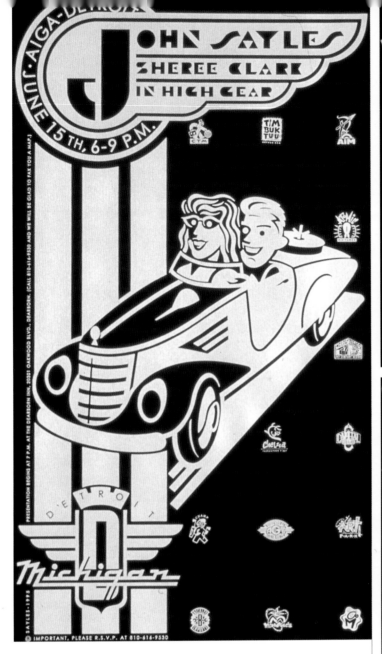

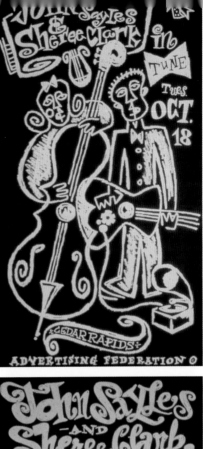

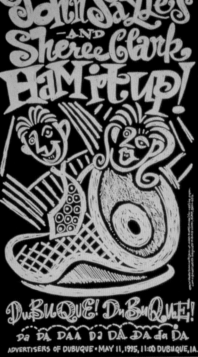

OPAQUE SILKSCREEN INKS

Client **Various professional groups**

Design **Sayles Graphic Design**

Art Director/
Designer/Illustrator **John Sayles**

Here is another example of opaque, silkscreen inks, this time on black paper. Not only do these designs give the impression of two-color jobs for the price of a one-color ink, but the dense black of the paper adds both a visual and a tactile quality that mere ink alone cannot achieve. Silkscreen inks cannot reproduce the fine-line quality of offset printing, nor can they register as well. But they come reliably close to 133-line printing.

TEXTURED PAPER

Client	*Gormutt Doggie Delights Dog Biscuits*
Design	*Heins Creative, Inc.*
Creative Director/	
Designer	*Joe Heins*

Uncoated paper with a textured surface requires very careful design. On the one hand, textured paper is wonderfully appealing to the senses. On the other hand, it creates a lot of printing headaches. Some of the ink printed on such a surface rides high on top of the ridges. But other ink sinks down between. Light is wildly scattered, meaning that you lose a lot of detail. To compensate, keep type and art fairly large and simple, as was done here.

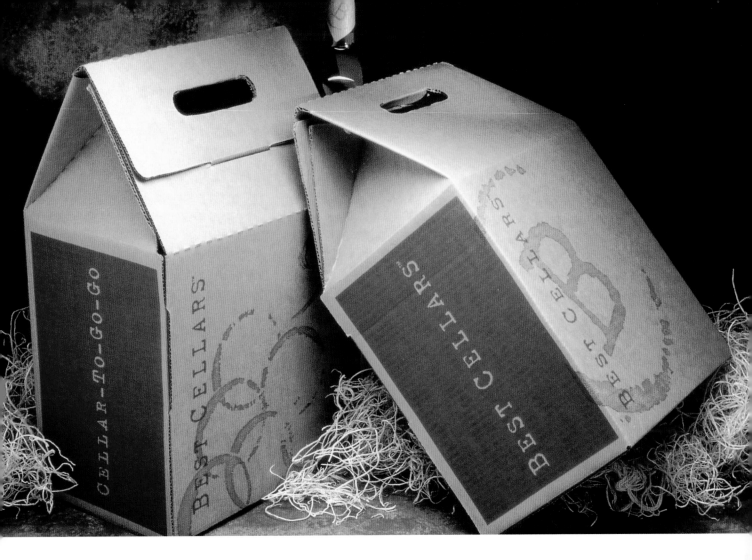

ROUGH PAPER

Client *Best Cellars*

Design *Hornall Anderson Design Works, Inc.*

Art Director *Jack Anderson*

Designers *Jack Anderson, Lisa Cerveny, Jana Wilson*

Ink on rough-surface paper loses detail because the ink sinks into the crevices. Rather than think of this as a disadvantage, however, designer Jack Anderson capitalized on it by creating a logo based on the stain that a wine bottle left on a linen tablecloth. The stain is supposed to look broken, so the ink and paper work perfectly together.

NO. IO PAR 4 — ARROWHEAD GOLF CLUB
Littleton, Colorado

UNDERCOLOR REMOVAL

Clients *National Golf Properties, Inc.*
Design *Douglas Oliver Design Office*
Art/Creative Director *Douglas Oliver*
Photography *Aidan Bradley*

Sometimes even on the best paper, ink can plug up on the press in the darkest shadow areas: the net result is mud. To prevent this from happening, use undercolor removal (UCR). In this prepress process, cyan, magenta, and yellow dots are reduced in neutral-black areas of the image and replaced with dense black. When the job prints, the cyan, magenta, and yellow ink fountains can be opened fully for highest saturation in the non-neutral areas, while black can run at one hundred percent in the deep shadows. The result: bright color without plugging.

FINE REGISTRATION

Client *Pegasystems, Inc.*
Design *Stewart Monderer Design, Inc.*
Art Director *Stewart Monderer*
Designer *Jeffrey Gobin*

My art director once specified a hairline rule to print one hundred percent magenta, eighty percent cyan. When I told him the press could not hold registration on a line that fine, he said he had designed it that way on purpose. "It will make the printer toe the line on quality," he said. Unfortunately, on the final pieces, the hairline printed as two rules. In the example shown here, the rules are specified to print in custom colors, so registration is not as critical.

IN-LINE CONFLICT

Client *The Sharper Image*
Design *in-house agency*
Art Director *W. Nelson*

Exercise the greatest control over color balance on
press by designing layouts that present no in-line
color conflicts. Here, each color image is in line
with black-and-white, allowing the press operator to
manipulate the ink fountain keys at will. Look at the
different color nuances achieved in the gray objects in
each photo. Such nuances would be impossible if there
were any in-line conflicts.

DIAGONAL CROSSOVERS

Client *Aamir Ahmad, Ocean Home Shopping Ltd.*
Design *Gavin Joule Design*
Creative Director *Aamir Ahmad*
Art Director *Sean Galligan*
Designer *Gavin Joule*
Copywriter *Michael Harvey*

Crossovers with diagonals are difficult to match. As the
press blanket revolves, each image on it strips ink
away, starving the following images directly in line.
This is true for square images as well as diagonals. But
square in-line images involve the ink fountain keys
uniformly. Diagonal images strip more ink as the angled
image increases in size across the page. So in-line
images are not starved uniformly, making crossover
matches tough. Here, the designer minimized the problem
by keeping one side of the diagonal crossover small. He
also kept other in-line images away from the crossover.

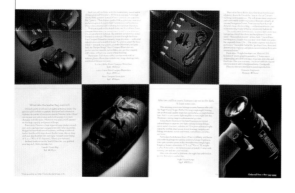

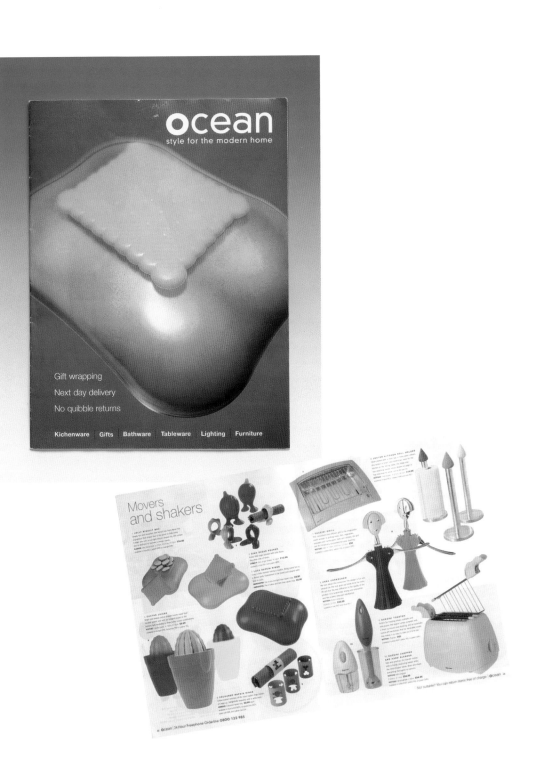

Editor Alain Lévy
Graphic design Placid
Printed in France

ROTRAUT

SCULPTURES-RELIEFS

CROSSOVER LAYOUTS

Client	*Rotraut*
Design	*Placid*
Artwork	*© Rotraut*
Editor	*Alain Lévy*

For a subject that's difficult to match in a crossover—such
as the wood here—try to lay out the two halves of the
image so they fall in the center spread. If you can't do
that, try to lay them out so they're in line with each
other, head to foot, on the press form. Barring that, lay
them out so that no other color subject is in line with
either page on the form. Whatever you do, however, don't
lay out the two pages across a signature break. That kind
of layout will give your production manager heartburn.

GHOSTS

Client | *Tommy Hilfiger Flagship*
Design | *Keenpac North America Limited*

Some in-line conflicts create ghosts. Ghosts are areas in an image that print lighter than other parts of the image. The only way to solve a ghosting problem is to stop it before you get on press. Lay out your pages so you don't get in-line conflicts. Or run a ghosting bar of color in the trim space along the bottom of your page. Or use inks that don't starve each other. These bags would show a ghost in the bottom navy panel if printed CMYK, because the red stripe would starve the magenta from the navy following it, whereas the white stripe would not. The reason you don't see a ghost here is that separate custom inks are used for the red and navy.

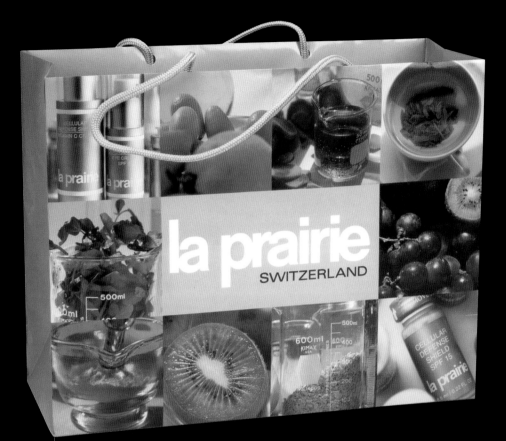

UNIFORM STARVING

Client | *La Prairie*
Art Director | *Ched Vackorich*

Ghosting is not a danger here because the images all line up with each other. The bottom images are starved for ink, true, but uniformly so. Therefore, you don't see a ghost. If the gray panel in the middle of the bag were darker, a ghost might show up there. But because the gray needs so little ink, no ghost appears.

DENSE BLACK

Client/Design	*frogdesign*
Arbiter	*Hartmut Esslinger*
Creative/Art/ Editorial Directors	*Steven Skov Holt, Gregory Hom*
Senior Designers	*Matthew Clark, Eddie Serapio*
Designer	*Thomas Preston Duval*
Guest Editor	*Phil Patton*
Photographers	*Hashi, Dieter Henneka, Steve Moeder, Sysop Craig Syverson*

A dense black background requires more ink than a
single plate can carry, even if the black prints one
hundred percent. If you can afford an extra plate,
add another "hit" of solid black to the entire
background. Or, if you are using a four-color process,
strip in a screen of forty percent cyan behind the
solid black.

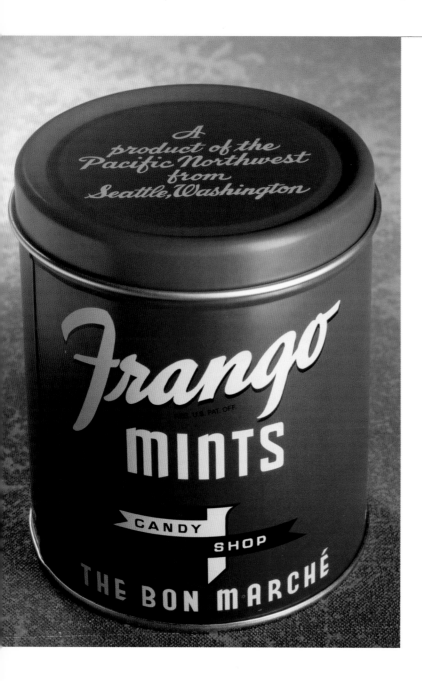

DOUBLE HITS

Client	*The Bon Marché*
Design	*David Lemley Design*
Art Directors	*Robert Raible, Kevin Gardiner (The Bon Marché)*
Designers	*Alfred Dunn (ca. 1936), David Lemley*

One way to get heavily saturated colors is to run them twice, as was done here. This works best if you are trying to enhance flat areas of color. If your design uses a halftone, try using a double-dot technique instead. Begin by shooting two negatives, for two printing plates. The first negative slightly emphasizes the highlight areas in the photo, with just enough flash exposure to keep a small dot in the shadows. The second negative is angled at 75 degrees and then shot for maximum shadow contrast, with no highlight dots at all.

WHITE ON WHITE

Client	*Tasty Talk Tea*
Design	*The A Company*
Art Director	*Jin Sato*
Designer	*Akino Takahashi*
Illustrator	*Eri Urabe*

One of the hardest things to print on a four-color off-set press is white on white. That's because all the detail is supplied by dots of colored ink. Use too much of any one process color, and the entire white takes on that color cast. To succeed with white subjects, balance your monitor to the separator's standards, view everything in 5,000-degree Kelvin light, and make sure the gray balance is neutral during separation. Once on press, monitor dot gain strictly. Only then will whites look white.

RICH REDS

Client | *Émigré Magazine*
Design | *The Offices of Anne Burdick*
Art Director | *Anne Burdick*
Creative Director | *Rudy Vanderlans*

Sometimes you get lucky on press and produce a red like this with CMYK inks. This is not a good thing, because it encourages you to think that you should always be able to do it. Really saturated reds are best achieved with a fifth color—CMYK just can't do the job very reliably, no matter how much you plead with the printer to boost the magenta and tweak the yellow.

HEXACHROME

Client | *Text 100 Group PLC*
Design | *Dietz Design Co.*
Art Director | *Robert Dietz*
Designers | *Robert Dietz, Denise Heckman*
Illustrator | *Doug Herman*
Copywriters | *Text 100, Robert Dietz*
Photography | *Keith Brofsky*

Hexachrome printing involves a six-unit press, with inks specially formulated for brightness: saturated yellow, bright cyan, enhanced magenta, black, intense orange, and bright green. The inks provide a greatly enlarged gamut of colors, exceeding that of some monitors. To use the Hexachrome system successfully, find a printer with experience—the only one on a learning curve should be you. In addition, expect to use higher screen values, better quality originals, and more total ink density (three hundred fifty percent). Also, expect to pay thirty to seventy percent more.

http://www.text100.com/annualreport1997

Stop Refresh Home Search Favorites

a strategy you're dead mate

Our approach Public relations consultancy comes in many forms. Some excellent, and some not. Some strategic, and some tactical. To us at Text 100, this distinction between strategic and tactical is all-important. This is perhaps why some companies call themselves PR agencies, rather than consultancies. At Text 100 we loathe agency thinking - which is little more than a telephone switchboard connecting journalists with spokes-people. In other words, it's a business requiring limited intellectual input. Our business, on the other hand, is built around adding intellectual value whenever possible. This means adding strategic thinking and market intelligence to the clients' businesses and advising them on all aspects of their conduct in the marketplace. For example, this might involve making small changes to a product's name, its positioning or even its functionality. It might also mean changing its launch date in order to take advantage of a particular media coverage opportunity.

But we don't stop at adding value through consultancy. The company has developed several distinct methodologies that start by attempting to define what a client company requires from PR in order to succeed. With a client's success defined in these terms, we then have a blueprint against which to judge our proposals. This is designed to reduce the time clients spend tracking our work, and frees them up to focus on other areas of their marketing activity.

Text 100 is Ireland's largest technology PR consultancy

TRUE DUOTONES

Client | *Applied Materials*
Design | *Gee + Chung Design*
Art Director | *Earl Gee*
Designers | *Earl Gee, Tani Chung*

True duotones are those made with two colors, both screened into halftones. You can make duotones by screening the two negatives the same and printing one in black and one in color, with the dots angled differently or offset from each other. Or you can make two different negatives, each recording a different portion of the photo. For example, you can make the colored negative record only the midtones and highlights, with the black negative picking up the shadows. Such a duotone increases the density range of the photo.

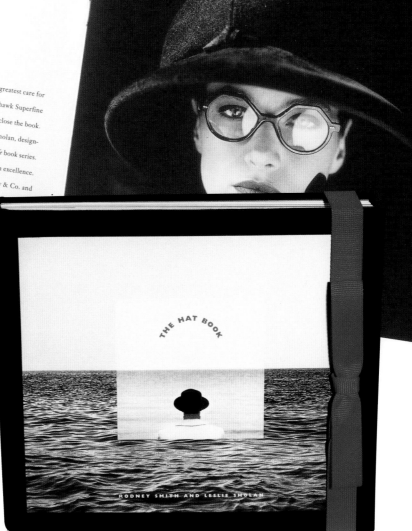

...uisitely produced photographic book, printed on the highest quality paper with the greatest care for ... The book will be 128 pages, with tri-tone black and white images on 100# Mohawk Superfine ...be special rice end papers and a red, grosgrain ribbon will tie around the cover to enclose the book. ...-winning, Dallas-based printer, will be handling the reproduction. ▲ Leslie Smolan, design-...cipal of Carbone Smolan Associates and the acclaimed designer of the *Day in the Life* book series. ...lan and her partner, Ken Carbone, have built an international reputation for design excellence. ...for the Louvre in Paris, the Museum of Modern Art, The St. Regis Hotel, Tiffany & Co. and ...ublicity for the book will abound in magazines, as will feature stories, and plan...re already in the works. ▲ Nan A. Talese/Doubleday will publish *The Hat B*...n *The Cat in the Hat* ©1957 by Dr. Seuss. Copyright renewed 1985 by Theodo...

WARM BLACK DUOTONE

Client/Design *Carbone Smolan Associates*
Designers *Leslie Smolan, Jennifer Domer*
Photography *Rodney Smith*

Not all duotones have to look like fake sepia. You can produce some interesting effects by using warm black inks. Black mixed with a small amount of rubine red or Pantone Orange 21, for example, takes on a warm cast without any hint of sepia.

SCREEN-TINT OVERLAY

Client *John Mancini*
Design *Michael Stanard Design, Inc.*
Designer *Kristy Vandekerckhove*
Art Director *Michael Stanard*

You can create a duotone effect without the expense of a true duotone by specifying a pale screen tint of color behind black-and-white art.

NO WHITE DOTS

Client *En direct journal, University of Franche-Comté*
Design *Catherine Zask*

Here is a duotone that is not a pure duotone. It has no true white. It is almost as if a screen of color from the type block above had floated down to cover the photo too. What might otherwise look flat instead looks organic.

COLORED HALFTONE ON COLORED PAPER

Client/Design | *"Say Ah!" Creative*
Art Director/
Designer | *Kelly D. Lawrence*
Photography | *Superstock*

Another way to simulate a duotone is simply to run a
one-color halftone print in PMS ink on a contrasting
paper color. Look at how different the dentist photo
appears on the Simpson Quest Bronze paper compared
to the white sticker on the diskette.

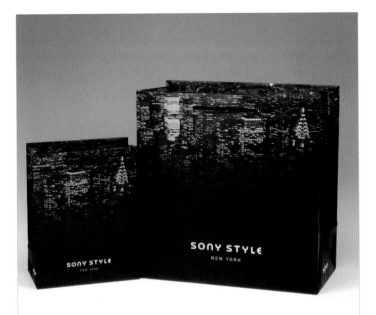

TRITONES

Client | *The Sony Style Store, New York*
Design | *Frankfurt Balkind Partners*
Art Director | *Kent Hunter*
Designer/Illustrator | *Stephen Hutchinson*

Tritones are like duotones with an extra plate. They aren't used in designs very often because they cost almost as much to print as a four-color job. But tritones can create more subtle, unexpected effects than a simple four-color photo because they use a customized palette. Of course, that makes proofing almost impossible. Allow extra time in the schedule for plenty of discussions between art director and printer. You don't want surprises on press.

PALE SCREEN TINTS

Client *REI*
Design *Olson Creative*
Designer *Janis Olson*
Editor *Cheryl Mikkelborg, REI*

Controlling pale screen tints can be very difficult. If multiple process colors are used to create them, the slightest variation in dot gain can change the entire hue. The problem is even more difficult when the screen tint crosses the gutter, as the green screen does here. Fortunately, the problem goes away completely if you specify a custom ink for the tint. Instead of fighting multiple ink fountains on press, you deal with only one. Simple.

RESTRICTED SCREEN TINTS

Client *Bombardier*
Design *The Greteman Group*
Art Director *Sonia Greteman*
Editor *Steve Phillips*

When screen tint colors are critical—as they are here in the orange bar that crosses the gutter - it is better to restrict the number of process colors used to composite the tint. One ink is better than two; two better than three; three better than four; and four will turn your printer's hair white. If you must use multiple screens, make sure one color dominates all the others. Minor variations in dot gain will then be masked by the dominant color.

PERSPECTIVES
Doing business in China is making a difference

REI's store and mail order teams are reporting an increase in questions from customers about REI's policies on manufacturing in China and selling other vendors' products made there. Some people believe that if we cease selling any Chinese-made product, the economic pressure will bring a halt to human rights abuses in that country.

My recent trip to China, as part of a 14-member delegation from Washington state, confirmed for me that REI's current course is the only way to influence human rights practices in China, which we all recognize are terrible and in need of change. REI's position is that economic interaction will continue to improve the lives of average Chinese people and contribute to a "peaceful evolution," a theme I will return to in a bit.

The delegation was led by Washington State Senator Pam Murray and included representatives from Eldery Cranes, Port of Seattle, Microsoft, Washington Wheat Commission, Boeing, US Bank, and Seafirst Bank. In 10 days, we visited Hong Kong, Beijing, and Shanghai.

It was an interesting time to travel to this area. Hong Kong reverts to Chinese sovereignty on July 1; and Most Favored Nation (MFN) trade status conferred by the US, along with China's application for membership in the World Trade Organization, are pending.

Senator Murray had the opportunity to officially address the Chinese Government on the issue of human rights. In a meeting with Chinese Vice Premier Li Langing, which I attended, she expressed the fact that human rights was a personal concern to her and the American people. She mentioned allowing the International Red Cross to visit Chinese prisons as a way to show small steps in the human rights area that would be helpful to those who support permanent MFN status as the vote nears in the US Senate. The delegation also talked about the potential of a "consumer backlash" against Chinese goods sold in the US due to concerns about human rights.

This meeting and my trip as whole left me with the reaffirmed conviction that isolating China will not improve the lives of people in China, but that continued involvement there will. Two meetings in particular encouraged me that REI's course in China is correct. The first was a briefing with the U.S. Consul General in Shanghai. He stated that, at recent as eight years ago, the daily lives of citizens were strictly controlled by their work unit through State-owned enterprises. Ration coupons for housing and vital consumer goods were given out by these work units, but the rapid rise of private service employment opportunities has changed this "iron rice bowl" control. "This represents the most dramatic change in China in 5,000 years," he stated.

The second encounter was with the Deputy Chief of Mission of the U.S. Embassy in Beijing. He, too, believes that China is experiencing a tremendous increase in the sphere of personal freedoms for the average citizen as more Western businesses operate in China.

Such experiences confirmed in my mind the premise of Nicholas Kristof and Sheryl WuDunn in their book, *China Wakes*, that the enormous amount of foreign investment, information exchange, and outside contact is creating a "peaceful evolution" in China. They write:

"Hard-liners worry that the spread of American ideas, movies, novels, music, and even dance styles is all part of a broad conspiracy to undermine Communist rule. Of course, they give us too much credit. But what a great idea! Peaceful evolution, in the sense of exposure to Western ideas, helped bring democracy to Spain in the 1970s, and peaceful evolution has helped bring freedom to Taiwan in the 1990s . . . To get peaceful evolution, we need more contact rather than less. We need more trade, more cultural exchanges, more engagement. So if we're serious about trying to make China a more open place, we should be threatening not a cut-off of trade but an expansion."

The conclusion I draw from my readings, conversations and observations is that REI is correct in adopting a policy of engagement and trade with China. Our team and our customers can rest assured that our own products are being manufactured under safe and fair conditions. I have seen the factories myself and they are monitored regularly by the product sourcing group at THAW. You can also be assured that REI is helping to bring about positive changes in human rights in China while bringing our members quality, affordable goods. The strategy of engagement and trade is working today.

Wally Smith

WHAT BRINGS 'EM BACK TO REI?

There's no doubt about it. Loyalty counts for a lot in this world, especially for businesses like REI that are facing more and more competitors.

Members who bring their business to REI year after year help make sure their cooperative will be here for the long haul.

Attracting and retaining the loyalty of members, so that they think of REI as their first and only source for outdoor gear and clothing, is the purpose of one of REI's three strategic objectives for building a competitive business. The strategic objective, in a nutshell, says that we need to understand what customers value and then deliver more of those attributes than our competitors do.

The first step in determining exactly what our customers value and to do that, Research Manager Ellen Meyer has designed a new survey method that replaces the old customer satisfaction and customer service surveys. The new Customer Satisfaction Surveys first ask members to identify the retailing attributes that are valuable to them, then asks them to rate REI and the competition on those attributes.

From 55 factors evaluated by respondents in late 1996, REI is focusing on the 15 named most important by customers, which are listed to the left. "We're strongest in the most important factors, which is a great start," Ellen said. "By really focusing on those things that are most important to members, we can meet their needs and keep them for life."

To begin honing REI's relationships with customers, there are more than a hundred specific actions that have happened or will take place this year. REI's senior management team hopes to see the meter move on the next survey, which will be performed in August. A few of the actions include:

- Reinvesting in each store's payroll the dollars saved by lowering Sunday pay to regular full pay instead of time-and-a-half. Because more sales people can be scheduled using the savings, sales help is more accessible to customers.

- Providing focused product training curricula on camping gear and footwear, to bolster the knowledge of our experienced sales people.

- Purchasing a new Mail Order system that will allow customers to place orders around the clock.

- Translating the full holiday catalog into Japanese for the nearly 60,000 members in Japan.

- Sending Gear Mail e-mails via rei.com to customers based on the topics they want to hear about.

"There's no silver bullet that makes a difference, but it meeting hundreds of small unique needs, we become distinctive in the minds of members," said Dennis Madsen, executive vice president and chief operating officer. "The objective is about finding the things that strike a chord with our customers, that make them feel personally connected and rewarded for being a frequent customer of REI."

ATTRIBUTE	REI BEST	ALL SAME	OTHER BEST
Knowledgeable salespeople	60%	22%	18%
100% guarantee	48	44	8
Highest quality products	51	32	18
Most consistent quality	52	33	15
Reasonable prices	44	27	29
Easy to return items	44	45	10
Experienced salespeople	60	22	19
Accessible salespeople	49	27	24
Carry products that I want	44	43	13
Sales help has technical information	62	19	19
When I call the store, I get the answers I need			
Store carries the brands I like	41	42	17
Readily available sales help	48	23	29
Always have my size	30	54	16
Always have what I need	39	44	17

Grant sees REI member-led expedition to summit!

Supported by an $1,075 REI Brand Expedition Grant, six REI members successfully summitted Mexico's 18,611 ft. El Pico de Orizaba late in March. Hoping to convey to fellow mountaineers the importance of minimum impact adventure, the Tacoma, Wash., climbers hauled more than 300 pounds of trash off the mountain's 13,000- and 14,000-ft. basecamps, depositing the trash in a designated landfill.

The team provided REI with expedition photos as well as in-depth REI brand product evaluations. The team gave high marks, along with suggestions for improvement, for REI's GeoMountain 4 tent and REI MTS 2 underwear. Of the tent, expedition leader Matthew Shupe said, "It's very easy to set up and take down and has good overall design, especially its dual entrances, vestibules, pole structure and fly attachment system."

The REI Brand Expedition Grant program is back this year after a one-year hiatus, along with the REI Brand Employee and Team Challenge programs. For 1997, REI has budgeted $24,000 for the expedition program, an increase of $14,000 over 1995 funding levels.

The REI Brand Expedition grants give REI gear in support of a limited number of REI member-led extraordinary expeditions in the specialty shop activities. This support is designed to encourage REI members to use REI brand product and help build loyalty and word-of-mouth support for the REI brand. Grant recipients also provide the opportunity to market and publicize interesting expeditions it has supported, further building the REI brand identity.

REI members may acquire guidelines through retail stores or by writing: REI Brand Expedition Grant Program, REI Public Affairs, P.O. Box 1938, Seattle, WA 98390-0800.

REI HELPS "REINVENT GOVERNMENT"

Why begin as a good idea to benefit members and the general public, has ended up being a "Vice Huntress" award from the office of Vice President Al Gore for efforts in "reinventing government."

The award was a "reinvention" involved in educating the Outdoor Industry Association. Gary THAW, their efforts in devising volunteer stewardship and funding to the area-wide National Forest.

OIGC represents the active recreational communities on national forests, national parks and other public lands. It earned two Vice Huntress since by and will extend grants on by fund March 31.

The effort, led on REI's side by John Sterngold, has become specialty shop managers at the flagship division at the popular volunteers desk into the store's by allowing county OIGC factory volunteers to aid THAW and their contribution to the federal government budget. The great working to reduce a connect annual rent the government couldn't worth for volunteer and that service is the living some in accommodate its operations.

Other partners in the project include the various officers of the US Forest Service, National Park Service and the Northwest Interpretive Association. Staff from these organizations and volunteers will be on site to assist visitors during store hours.

THAW started opening ceremony honored members of the store staff and some of REI's service group managers along for the presentation. US Department of Agriculture Undersecretary James Lyons attended to present partners with the Silver Huntress award. REI has committed to a connection established by the two vice-presidents, to recognize efforts to save taxpayer money and re-invent government efficiencies.

MIXING TINTS AND PHOTOS

Client *Princess Cruises*
Design *Lisa Juarez, Princess Cruises*
Editor *Julie Benson, Princess Cruises*

If you specify a background tint in a design that also
includes four-color photos, like this one, make the
background as easy to control on press as possible.
Otherwise, when in-line color conflicts arise, you will
have to decide whether to match the four-color photos
or the background tint. To avoid problems, use a fifth
color for the background. Or specify only one process
color as the screen tint. Or print the whole job on
colored paper and eliminate screens altogether.

GREAT SCREEN TINTS

Client/Design	*Wizards of the Coast®*
Creative Director	*Rich Kaalaas*
Art Director	*Jayne L. Ulander*
Designer	*Craig Hooper*
Illustrator	*Christopher Rush*
Production Manager	*Joy Fortney*

Wizards of the Coast® requires great color fidelity
because the packaging colors have meaning within the
games. So the designer built each screen color using
only two CMYK colors. As a special mark of appreciation
for his restraint, production managers everywhere
pause for two minutes of silent tribute.

EASY MATCHES

Client | *Maintenant magazine*
Design | *Placid*

This screen works for several reasons. First, it involves a restricted number of process colors. Second, it is not too light to get lost in plating, yet it is dark enough to provide contrast for the reversed-out type. Third, the photos are all in color balance with the screen or are not affected by the screen color. Look at the pink cast in the photo at the bottom right, for example. It needs plenty of magenta, as do the colors surrounding it. The photo on top of that column, by contrast, has no magenta at all.

SCREEN-TINT TRICKS

Client | *La vie en rose, Éditions Plume*
Design | *Louise Brody*

Flat background screens like these are best printed with a custom ink, not with built-up CMYK screens. CMYK screens are almost impossible to control over such a wide area of paper, due to in-line conflicts, variable dot gain, and paper stretch. If you must use CMYK, stay away from specifying any tint at fifty percent. In a fifty percent screen, the ink dots just touch each other at the corners. If they touch more than a tiny amount, then a bridge of ink can quickly form, expanding the dot uncontrollably and creating an entirely unwanted hue.

PIN DOTS

Client *Baja Bud's del Norte*
Design *Mike Salisbury Communications*
Art Director *Mike Salisbury*
Designer *Mary Evelyn McGough*

When designing vignettes, make sure your printer can carry the smallest halftone dot you specify. Pin dots can sometimes disappear in the film during the plating process or on press. It is not enough to say that a printer should be able to print a design. The question is, can he? In this case, the vignette in the letter *j* of Baja looks fine here but might present too much of a challenge for a less-than-clean printer.

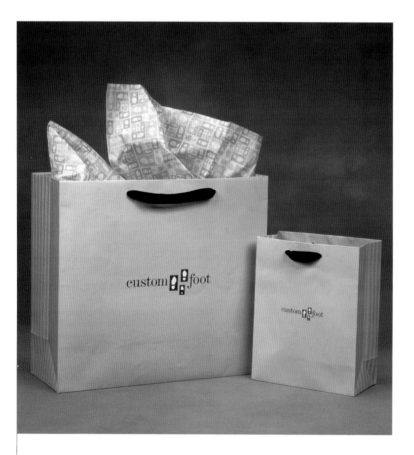

PALE COLORS

Client *Custom Foot*
Design *Alexander Isley, Inc.*
Art Director *Alexander Isley*
Designer *Collen Sion*

Another reason for choosing a custom ink for pale backgrounds is that you can print the ink as a solid. Ink at one hundred percent is very easy to control on press.

NO LARD.
NO MSG.
NO JUNK.
NO WHERE.

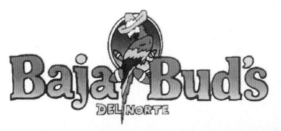

Baja Bud's
DEL NORTE

WINNETKA AND VENTURA

OUT-OF-GAMUT CMYK

Client	*Green Concepts*
Design	*Watts Graphic Design*
Art Directors/	
Designers	*Helen Watts, Peter Watts*

Four-color process inks can reproduce many of the
colors found in nature. But CMYK falls short when it
comes to reproducing intense oranges, hot purples,
deep reds, anything fluorescent, and even certain
greens, such as the one here. Use custom inks instead,
and mix them to the desired hue.

LOGO COLORS

Client	Cearns & Brown
Design	Wolff Olins
Creative Director	Lee Coomber
Designers	Phil Rushton, Kerry Humphreys, Sam Wilson
Photographer	Mike Russell
Illustrator	Pete Denmark
Production	Roy Bowkett, Alan Coterell

When color is used as a logo identity, as it is here (Pantone 343 green), you are almost always better off using a custom-mixed ink rather than process inks. With custom inks, you don't have to fight variations in screen values during prepress, in-line color conflicts, unpredictable dot gain, or other pressroom black holes.

CEARNS & BROWN

Pitted black olives
in brine

2.27 litres

CEARNS & BROWN

Tea
100 tagged tea bags

CEARNS & BROWN

Natural breadcrumbs

LOGO COLOR VARIATION

Client *Caja de Pensiones, Barcelona, Spain*
Design *Landor Associates*

Logo color is important for the identity of this Spanish bank, but the distinctive star and circles are even more important . A visual image this strong can tolerate quite a bit of color variation without losing its identity. Look at the blue printed on the kiosk, the bus and the building. On the kiosk the blue appears almost cyan. On the bus it is more royal blue. On the building it is a pale sky-blue. Despite these differences, enough color fidelity remains for people to identify the logo.

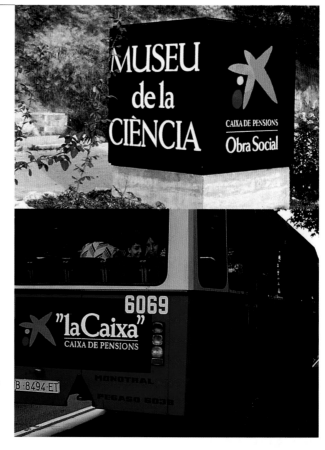

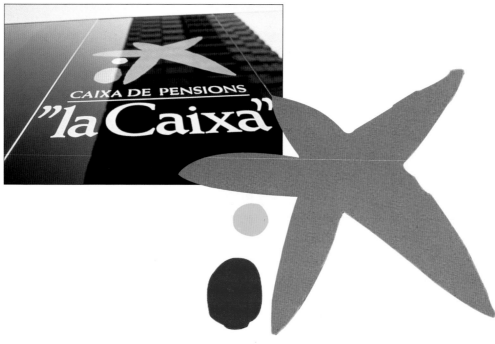

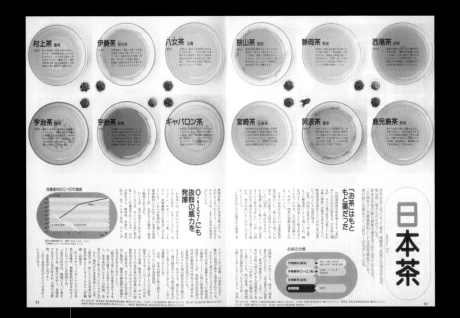

COLOR-BALANCED PROOFS

Client | *Evah magazine*
Design | *Issen Okamoto Graphic Design Co., Ltd.*
Art Director | *Issen Okamoto*

When depicting products that have to match the
originals perfectly, such as the different greens of
the teas shown here, color-balance your entire
signature before printing. To do that, have a color
proof made of the composited signature, even
though the cost is high. Then take a look at the
in-line ink conflicts you are going to get on press
and adjust them before you print.

FOUR COLOR GRAYS

Client *La Maison de la musique*
Design *Atelier Pascal Colrat*
Designer *Pascal Colrat*

Four-color grays are some of the hardest colors to control on press. The least little dot gain or misregistration throws the whole gray out of neutral and into a color cast. During the color okay, work with the printer until you get the balance you want. Then sign the sheet and hold the printer accountable for keeping the colors balanced. If a job is really critical, ask for sheets to be pulled and time-stamped at regular intervals throughout the press run.

THREE-COLOR BEIGE

Client *Le Journal des Arts*
Design *Louise Brody*

Pale, three-color beige is another neutral color that is difficult to control on press. You can help yourself by laying out images that don't conflict with each other on press, as the designer has done here.

EXTRA PRESS UNITS

Client *The Royal Mail*
Designer *Kristine Matthews*

When the Royal Mail bought a new nine-color press, they tested it by running stamp sheets designed by students at London's Royal College of Art. When you have this many press units to work with, you can devote all of them to ink colors (and save yourself the grief of trying to match CMYK to the real world). Or you can reserve some units for spot varnishes, metallics, fluorescents, or other special effects. Always find out ahead of time which press the printer plans to put your job on. If you'll be getting some extra units, you can design a use for them that will only cost you a minimal amount for plates and ink.

3/2 PRINTING

Client *Synergy Group, Ltd.*
Design *Vaughn/Wedeen Creative*
Art Director *Steve Wedeen*
Designers *Steve Wedeen, Adabel Kaskiewicz*

Any time you can save production money on a job, you can pass along those savings to your client. More important, you can pass along the sense that you care about the client's pocketbook. Here, the designers printed six separate press sheets. On each sheet, they chose three PMS colors for one side and two for the other. So they had the option of using 30 different colors in total for the price of a three-color job.

FOLLOWING FORMS

Client *IDSA Michigan*
Designer *Barry Hutzel*

Another trick to save money is to specify your job so that similar forms follow each other on press. If you print one 16-page, four-color signature followed by another 16-page, four-color signature, the press requires minimal washup. To capture following-form savings, make all signatures alike. An exception is this job, which the designer printed sheetfed with one-color ink. The cover was printed in black ink on red paper and the body in red ink on white paper. Because the job was sheetfed, the printer could change paper stock easily with minimal washup.

INTERLEAVING

Client *California Center for the Arts*
Design *Mires Design*
Art Director *John Ball*
Designers *Deborah Horn, John Ball*

Still another trick to save money on ink and plates is to print interleaved signatures. An interleaved signature is really two signatures, printed on two separate press lines and folded together at the end of the press lines. Typically, one signature is printed four-color; the other is printed one-color. Not only do you save on makeready and binding charges, but you get the benefit of spreading out color pages more evenly throughout your book. When the two signatures are folded together, the full-color pages alternate with the one-color pages four at a time. Not every printer configures his equipment for interleaving capability, so ask about it before you design.

INK NEGOTIABLES

Client	*Sealaska Corporation*
Design	*Hornall Anderson Design Works, Inc.*
Art Director	*Jack Anderson*
Designers	*Jack Anderson, Katha Dalton, Heidi Favour, Nicole Bloss, Michael Brugman*
Illustrators	*Various, from Sealaska archive*
Photography	*Various from Sealaska archive, David Perry, Mark Kelley, Clark Mishler, Image Bank, Alaska Historic Museum, University of Washington*

When bidding out printing jobs, especially jobs with long press runs, don't forget to leave some negotiating room for ink prices. No, you can't get the printer to take a few cents off per pound. Ink is not like broccoli. But if you know that your design will use light ink coverage—maybe it is mostly type with few bleeds and no dense four-color—then put that in the bid specifications and ask for a price reduction. Similarly, if the job involves a lot of full bleeds and dense coverage, put that in too, and expect to pay a little more. Fair is fair.

LIGHT INK COVERAGE

Client | *Ise Cultural Foundation*
Design | *Toda Office*
Designer | *Seiju Toda*

This is an example of light ink coverage. You should be
able to negotiate a lower ink cost for a job like this.

BACKGROUND EFFECTS

Client *GE Capital Assurance*
Design *Hornall Anderson Design Works, Inc.*
Art Director *Jack Anderson*
Designers *Jack Anderson, Lisa Cerveny, Susan Haddon*

The color we see depends to some extent on the background that surrounds it. Dark colors printed on a dark background look lighter than the same dark colors printed on a light background. Notice how much lighter the left side of the orange display type looks compared to the same type on the right. Compensate for this effect by making your tints one or two percent darker when you print them on a dark background.

READABLE COLORED TYPE

Client | *Cranbrook Art Museum*
Design | *Geoff Kaplan*

When overprinting type, pay attention to readability.
While the human eye can see tones that differ by only
two percent, it is not necessarily comfortable to read
a lot of type like that. In this design, take a look at
the type overprinting the screened blue tire. The solid
brown is a little hard to read, but not nearly as difficult
as the type overprinting the large blue graphic element
above. If your design absolutely requires such a
juxtaposition, at least run the type large and without
serifs, as this designer has done.

representing the passions

Predoctoral and Postdoctoral

The Getty Research Institute **Fellowships** 1998–2000

for the History of Art and the Humanities in 1998–1989 will bring scholars together to study the variety of

ways in which the passions have been represented and classified.

"The passions"—"strong, ungovernable feelings"—
seem to demand representation even as by their very nature they
expose the limitations of representation.

Perhaps because of their intensity, there seems to be an important social need to name the passions, thus distinguishing them from one another, and to develop gestural and rhetorical conventions and codes about them. Yet the passions' ungovernability threatens either to break through or to be lost by cultural conventions and codes that attempt to fix, ritualize, and control them. How does the unreasonable, the ungovernable, become an object of knowledge, of manipulation, if knowledge and manipulation imply control or containment? How has discussion of the passions formed a basis for the study of character or of the psyche? How do traditions of performance and languages of gesture cope with the dilemma of extreme emotional states that may destroy the frame of presentation? How is experience of these states related to these performances and languages? How are the passions of an individual to be reconciled with the collective morality of the community—and collective passions with the requirements of social order? Do some passions depend upon obstacles for their very existence? What is gained by the liberation of the passions? What is lost? These are old questions in the Western tradition, in some ways as old as the tradition itself. Do these questions arise in non-Western traditions, and if they do, what forms do they take? In the visual arts, philosophy, theater, literature, music, medicine, and political economy past responses to such questions have greatly influenced one another. At the Getty Research Institute researchers in these areas will have the opportunity to benefit from the exchange of ideas as they address old questions about representing the passions and formulate new ones.

THE GETTY RESEARCH
INSTITUTE FOR THE HISTORY OF
ART AND THE HUMANITIES
invites applications for two-year predoctoral and postdoctoral fellowships. These fellowships begin September 1998 and end June 2000. Successful applicants will be in residence during that period at the Getty Research Institute in Los Angeles, California. These fellows will join a distinguished group of scholars, artists, and other cultural figures from around the world in the Research Institute's Scholars and Seminars Program. Getty Fellows will have the opportunity to pursue their own projects, take part in the intellectual life of the Research Institute, make use of its collections, and participate in a weekly seminar based upon the theme of the program that year. For the residual year of the fellowship, 1999–2000, the theme will be "Representing the Passions."

Applications for these two-year predoctoral fellowships—predoctoral and postdoctoral—in the arts, humanities, or social sciences will be evaluated first and foremost in terms of how the proposed dissertation or book bears upon the theme "Representing the Passions." Research projects that look beyond the narrow history of the humanities will be of special interest. Applications must be received by December 15, 1997. Applicants are asked to submit information to the Research Institute. They may obtain application materials by calling the Research Institute. For an application form, or for more detailed information on the Getty Research Institute and its current activities, applicants can write to the Research Institute at http://www.getty.edu.

For information about predoctoral and postdoctoral fellowships in the history of art and the humanities, please contact: The Getty Grant Program, 1200 Getty Center Drive, Suite 800, Los Angeles, CA 90049-1685, Tel (310) 440-7374, Fax (310) 440-7703.

PREDOCTORAL FELLOWSHIPS
Eligibility. Candidates for a doctorate in the arts, humanities, or social sciences, who expect to complete their dissertations during the Fellowship period. Tenure. Fellows spend the academic years 1998–1999 and 1999–2000 in residence at the Research Institute; the fellowship stipend is $16,000 for each of those academic years (for a total of $32,000). Fellows are granted the use of an apartment in the Getty Scholar apartment complex; fellowships are not renewable. Application Requirements. Curriculum vitae and abstract of dissertation, two-three page statement of research project, writing sample (no more than thirty pages), three letters of recommendation (one from outside the applicant's field of specialization), and confirmation from academic institution that coursework has been completed and qualifying examinations have been passed.

POSTDOCTORAL FELLOWSHIPS
Eligibility. Recipients of a doctorate in the arts, humanities, or social sciences awarded since December 1990, who are rewriting their dissertations for publication. Tenure. Fellows spend the academic years 1998–1999 and 1999–2000 in residence at the Research Institute; the fellowship stipend is $30,000 for each of those academic years (for a total of $60,000). Fellows are granted the use of an apartment in the Getty Scholar apartment complex; fellowships are not renewable. Application Requirements. Curriculum vitae and abstract of dissertation, two-three page statement of research project, writing sample (no more than thirty pages), three letters of recommendation (one from outside the applicant's field of specialization), and confirmation from academic institution that doctorate has been awarded.

SEND APPLICATION.
POSTMARKED NO LATER THAN
DECEMBER 15, 1997 to:
The Getty Research Institute, Attn: C.A.
Getty Research Institute for the History of Art and the Humanities, 1200 Getty Center Drive, Suite 1100, Los Angeles, CA 90049-1688.

KNOCKED-OUT TYPE

Client | *Raygun*
Design/Art Director | *Chris Ashworth*

When type is knocked out of a fairly uniform background,
it is easier to read. Compare the readability of the poster
on the left with the one on the right. Even though the
red display type on the right is big, simple and red,
it is actually harder to read than the grungier type on
the left. In these examples, emotion drives the reader
to persevere.

REVERSED-OUT TYPE

Client | *Getty Research Institute for the*
History of Art and the Humanities
Design | *The Offices of Anne Burdick*
Art Director | *Anne Burdick*

While this poster is visually sumptuous, reading
reversed-out type is hard on the eyes. This is partly
because people aren't used to reading it, so it slows
them down. But reversed type also produces a halo
effect around each letter, as the eye bounces between
the dark background filling the negative space around
each letter and the white letters themselves. If you
must use reversed type, restrict the amount readers
must see, and make the design so compelling that
readers will have the patience to stick with you as
they wade through it.

Milk for 25,000 homes

ALL IN A
DAY'S
WORK

OVERNIGH

HUNDREDS OF TRUCKS TRAVEL

THE TOLLWA

BRINGING AGRICULTURAL PRODUCT

FOR OUR BREAKFAST TABL

FROM AREA FARMS, MAKING SUR

FRESH FOOD

REACHES MARKET EACH

MORNIN

The Illinois Tollway **9** 1996 Annual Report

TYPE ON PHOTOS

Client	*Illinois State Toll Highway Authority*
Design	*Froeter Design Company, Inc.*
Art Director/	
Designer	*Chris Froeter*
Copywriter	*Jeanette LoCurto*
Photography	*Tony Armour*

Putting type on an image requires care. You don't
want the reader's eye to lose focus or bounce around.
Here, the designer cleverly reversed out type in the
dark portions of the photos and overprinted type in

3 DE MAIO

CONCURSOS DE MODELO E ANDAMENTOS/CAVALOS DE SELA/PROVA DE TRAVADO E GALOPE

2, 3 E 4 DE MAIO DE 1997 CÂMARA MUNICIPAL DE LAMEGO

LAMEGO

GABINETE DE APOIO EMPRESARIAL DO VALE DO DOURO

DARK AND LIGHT TYPE

Client | *Gabinete de Apoio Empresarial do Vale do Douro*
Design | *João Machado, Design Lda.*
Designer | *João Machado*

Faced with the problem of putting type over a dense
image alternating with white, this designer elected
to overprint some type and reverse out the rest. What
could be a jarring design is unified by the strong
curving lines of the type.

OUTLINE TYPE

Client | *The Louvre*
Design | *Philippe Apeloig*

Sometimes setting type with a thin outline can solve
a difficult contrast problem, especially when type
has a busy background. Here the hieroglyphic
background is dense enough for ordinary reversed-out
type. The dark/light contrast of the cloud on the left
is another story.

BOXED TYPE

Client | *Theatre de la Commune Pandora*
Design | *Malte Martin Atelier Graphique*
Designer | *Malte Martin*

Here are two treatments of type over dark/light
subjects. On the left, the type is reversed out of
boxes of flat color. In other designs, this treatment
often looks clunky. But here, the boxes echo the
stairs in the photo and draw the design together.
The type is extremely legible. On the right, the boxes
of type are not flat color, but alternate light and
dark. The type is very difficult to read reversed out
against the clouds, which simply have too few dots
to provide enough contrast for the type.

A DIFFERENT TYPE BOX

Client *L'Envers des Villes magazine*
Design *Toffe*
Designer *Christophe Jacquet*

For a unique solution to type that must print over both a light and a dark background, take a look at this treatment by Toffe. He has reversed out a box with a heavy black rule squarely in the middle of an upside-down photo. Imagine what the type would have looked like if it had been reversed out of the photo directly or overprinted.

TINTED TYPE

Client *Christian Lacroix*
Design *Didier Saco Design Graphique*
Designer *Didier Saco*

Colored type can be an effective design tool—but only if it prints perfectly in register. The best way to print colored type is to use custom inks, as shown here. With custom inks, you can set type as small as you like, print serifs and strokes as fine as hairlines (or finer), and carry a lot of text without eyestrain. None of this is possible if you are trying to register one process color to another.

CHRISTIAN LACROIX

« LE GRiLLoN »
UN PETIT ANIMAL PROVENÇAL QUI ACCOMPAGNE SES PROMENADES
AU FIL DES ÉVÉNEMENTS DE LA MAISON

m a r s 1 9 9 7

LACROIX, 10 ANS

Lacroix, 10 years

Cette année, la Maison Christian Lacroix a 10 ans. Sans tomber dans la manie si contemporaine de la délectation du passé et du culte des décennies, un anniversaire reste un anniversaire, moins comme une célébration que comme un retour sur soi. Il s'agit peut-être, à l'heure où l'on grandit, de se replonger dans ses racines, de cultiver sa mémoire, de faire un bilan du moment passé pour en tirer tous les enseignements possibles.
Tout au long de cette année, *Le Grillon* se propose d'évoquer ce morceau de vie écoulé au travers des différents événements — internes commes externes — qui ont accompagné la Maison. Commençant par le commencement, Christian Lacroix a répondu à nos questions.

Le Grillon — Que représentent ces dix ans ?

Christian Lacroix — Cette période des dix ans est pleine d'enseignements et, par là même, riche en potentiel d'évolution pour la maison. C'est maintenant que nous pouvons commencer à vérifier ou à contredire nos intuitions passées ; que nous pouvons commencer à mesurer le pourquoi de nos succès et de nos erreurs. Avec le recul, 1987 nous apparaît aujourd'hui comme un véritable moment de grâce, celui où nous avons eu des intuitions pour des décennies. C'était une époque de prépondérance parisienne, l'apogée du « chef-d'œuvre obligatoire », une époque où la signature comptait plus que le reste. C'était aussi le moment pour être différent, pour cultiver un écart, imposer une différence. Ce que nous avons fait à ce moment-là, dans l'enthousiasme des débuts, est un capital qui n'en finit pas de nous apporter.
Bien sûr, certaines choses ont mieux vieillies que d'autres, et ce sont souvent les plus folles, les plus « à côté », celles faites le plus souvent dans l'urgence qui ont le mieux résistées ; je pense par exemple aux salons du Faubourg Saint-Honoré, réalisés par Garouste et Bonetti, ou encore à certains univers stylistiques des débuts, comme le télescopage des époques et des folklores.

This year, the House of Christian Lacroix is ten years old. Without succumbing to the highly contemporary mania of delighting in the past and worshipping decades, a birthday remains a birthday, not so much as a celebration but as an occasion to do some soul-searching. It may be the opportunity, as one grows up, to go back to one's roots, to cultivate one's memory, and to assess the past in order to benefit from all its potential lessons. During the entire up-coming year, *Le Grillon* will discuss elements of this part of life by evoking different events — interior or exterior — which have helped shape the Maison. Let's start at the beginning, with Christian Lacroix's answers to our questions.

Le Grillon — What do these ten years represent ?

Christian Lacroix — The past ten years have taught us many lessons to teach us and are full of potential directions for the House. Now is the moment to start appraising or contradicting our past intuitions ; to start measuring the reasons for our successes and failures. With the benefit of hindsight, 1987 now appears like a true moment of inspiration, a blessed moment when we had intuitions for decades. Paris was foremost, it was the time of the « obligatory masterpiece », an era in which the signature was crucial. It was also the right moment for being different, to cultivate a gap, to impose a difference. What we did then, in the enthusiasm of the beginnings, represents a capital which does not end to offer its advantages bearing endless profits.
Of course, some things age better than others, and those which best stood the test of time are often the wilder ones, the more marginal ones, those created in a state of urgency ; I am thinking, for example, of the fitting-rooms of the Faubourg Saint-Honoré, designed by Garouste and Bonetti, or of some early stylistic atmospheres, such as the juxtaposition of folklores and eras.

.3.4.5.6.7.8.9.10.1.2.3.4.5.6.7.8.9.10.1.2.3.4.5.6.7.8.9.10.1.2.3.4.5.6

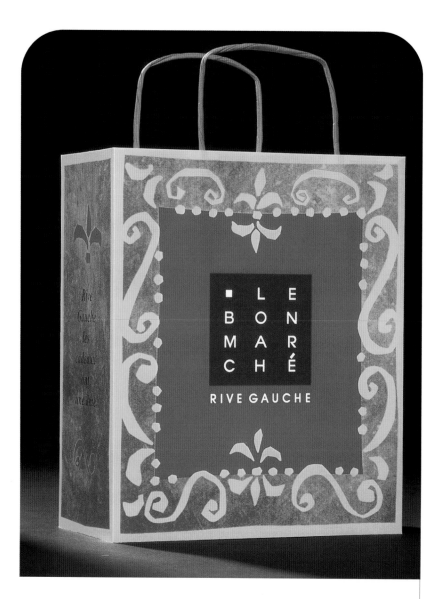

VARNISH ON UNCOATED PAPER

Client	*Le Bon Marché Rive Gauche*
Design	*Carré Noir*
Art Director/	
Designer	*Béatrice Mariotti*

Kraft paper, even when bleached white, usually has low brightness. It also has great strength. You can use the strength of this paper and still keep the brightness of your designs if you specify solid PMS colors and varnish the finished product. Whenever you plan to varnish a printed piece, make sure the printer knows about it ahead of time so he can select a varnish that is compatible with the inks. Communication is even more important if the printed piece is going to be glued. Glues won't stick if the varnish is too hard or slick.

FIFTH COLOR VARNISH

Client *Amazonia Expeditions*

Design *Asylum*

Art Director/

Designer *Cheryl Dasher*

In-line press varnish applied as an overall fifth color, as was done here, can add a sense of lushness to designs for not a lot of money. It might be a cheaper option than buying glossier, cast-coated paper.

SPOT VARNISH

Client *Tails of the City*
Design *Creative Division of Max Pack*
Designer *Kit Bauer*

To maximize the contrast between matte and gloss
surfaces, try spot gloss varnish. Just knock out the
desired area when submitting your prepress and add
a varnish plate at the end of the press line. (This
requires an extra press unit, just as an additional
color would.) Here, spot varnish over matte lamination
highlights the bright red of the fire hydrant.

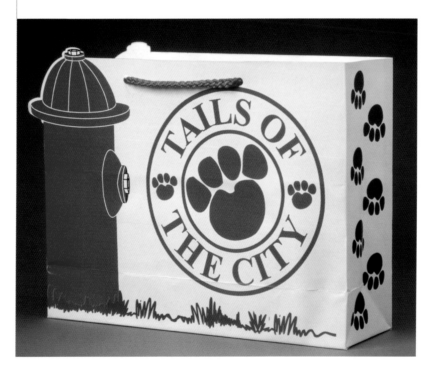

MATTE VARNISH

Client *Fashion Place Mall*
Design *Harris Volsic Creative*
Creative Director *David Volsic*
Illustrator *Rob Blanchard*

Not every varnish has to shine. Here, the designer
wanted the scuff protection that varnish provides but
without the shine that would have detracted from the
flat illustration. Matte varnish was the answer. If you
decide to use matte varnish, choose the hardest one
available. Any scuffing on matte varnish shows up as
shiny patches.

NON-YELLOW VARNISH

Client *Mall of America*
Design *Bardwell & Company*
Art Director/
Designer *Colin Bardwell*
Illustrator *Coco Masuda*

One nice advantage of a durable shopping bag is that it provides free advertising for your clients. For designs with a long shelf life, stay away from varnishes that might yellow over time. Discuss the end use of your design with the printer, and explain the job's shelf-life needs. It shouldn't be your responsibility to select a specific varnish formulation, but it is your responsibility to give the printer all the facts.

VARNISH FOR FOOD PACKAGING

Client *Millennium Conference Center and Hotel*
Design *NRI Digital*
Designer *Michael Tarricone*

If you are going to put varnish on printed packaging for food, as was done here, make sure the varnish is low odor and nontoxic.

UV VARNISH

Client/Design *Saks Fifth Avenue Everyday*

UV varnishes are applied off-line, overprinting offset inks. They are cured with ultraviolet light and provide exceptional gloss and rub resistance. If you plan to use a UV varnish, be sure to tell the printer ahead of time. He needs to know so that he can formulate your regular inks to be compatible.

GLOSSY AND MATTE CONTRAST

Client *SmarTalk Teleservices, Inc.*
Design *Douglas Oliver Design Office*
Art/Creative Director *Douglas Oliver*
Photography *Jeff Corwin*

Basic black doesn't look so basic when you change the glossiness of the ink. Not only can you contrast matte-black ink with process black, you can also add more varnish to process inks to make them shinier. Or you can overcoat with varnish. Varnish can be applied at the same time as you print the job (using the last unit of the press for varnish instead of for regular ink). Or you can apply varnish off-press using a separate one-color press. Varnish applied off-line produces a shinier gloss.

"Dad's taking me around the state this summer so I can compete with the junior rodeo. Mom told me to call and let her know how I'm doing. I try to call her every night, but sometimes I'm too tired."

FRESH METALLIC INK

Client	*Rockport Publishers*
Design	*Stoltze Design*
Cover Image	*Nesnadny + Schwartz, The Progressive Corporation Annual Report*

When using metallic ink, especially copper (or bronze), as in this example, make sure the ink is fresh. The metal powder in the ink can tarnish when exposed to air. Silver metallic inks made from aluminum do not tarnish.

TRAPPING METALLIC INK

Design	*Kenzo Izutani Office Corp.*
Art Director	*Kenzo Izutani*
Designer	*Aki Hirai*
Photography	*Toru Katoh*

Because offset inks are transparent but metallic inks are opaque, you have to be careful when using the two together. Pay attention to trapping and the order of the inks as they are laid down on press. Metallic inks, such as the gold here, should go down last, with some overlap over the process inks to cover up minor variations in trapping.

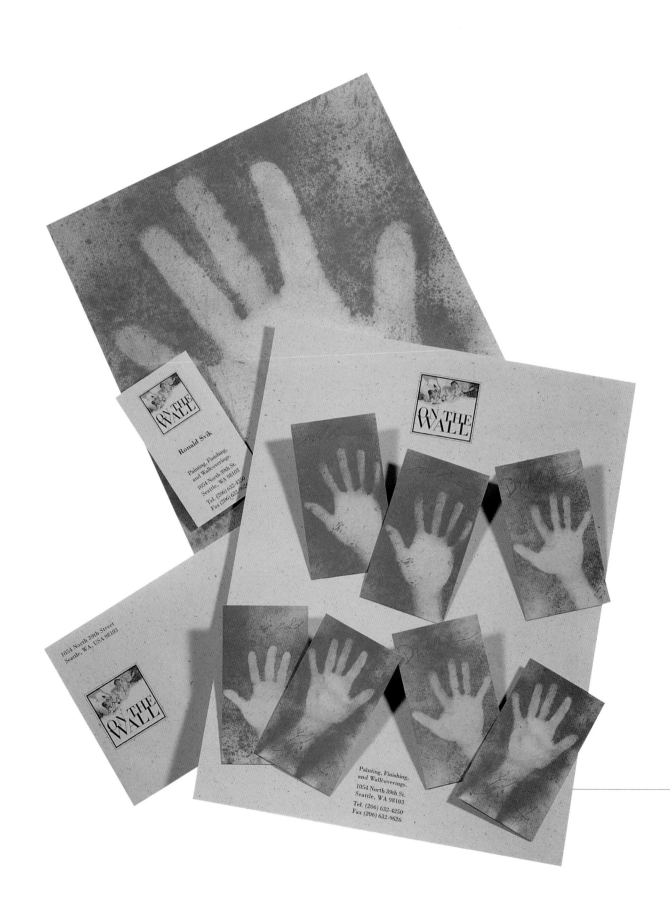

The Wadsworth Atheneum prese...

Eugenia Zuckerman and Dennis Helmrich

in *Spring Serenade*
Saturday, March 23, 1996
at 8 p.m. in the Aetna Theater
at the
Wadsworth Atheneum

METALLIC SCUFFING

Client	On the Wall
Design	Rick Eiber Design
Art Director/ Designer	Rick Eiber
Illustrators	Dave D. Weller, Gary Volk

Metallic ink (here metallic over one color on Speckletone paper) gives a profound gloss to designs that mere varnish cannot achieve. But metallic inks are subject to scuffing. You can protect them with a light overcoat of varnish, but that will diminish the gloss. An outer wrapper or envelope is the best protection, especially if you plan to mail the piece.

SUBTLE GLEAM

Client	Wadsworth Atheneum
Design	Atlantic Design Works
Art Director/ Designer	Stacy W. Murray

Metallics on rough-surface paper lose some of their gloss because the paper scatters light away from the eye. For a brightly shining metallic on uncoated paper, use foil, which is unaffected by the paper substrate. For more subtle effects, however, try metallic gold or silver inks anyway. In this example, the gold ink sank into the paper, diminishing the metallic gleam and creating a kind of old-gold look.

FOIL GLITTER

Client | *Seaman Schepps*

Metallic inks gleam because real metal powder is
put into them. When the ink vehicle dries, the metal
stays on top, where it can reflect the most light.
But the ability of ink to reflect light is nowhere near
the foil's reflectivity. When you need real glitter, go
for foil.

FOIL BLISTERS

Client | *CBS*

Of all metallic inks, silver is the shiniest. But even metallic silver ink cannot reproduce the glitter that hot-stamped foil can.

THE SHINIEST SILVER

Client	*Die Works*
Design	*Webster Design Associates, Inc.*
Designer/Illustrator	*Andrey Nagorny*

When designing foil images, keep color areas small, as this designer did. Large-scale applications of foil often result in blisters, which can form when the heat used to apply the foil turns the water in the paper into steam. Because the foil is nonporous, the steam can't escape, causing bubbles to form under the foil.

Ringstr. 99A
12105 Berlin
Tel/Fax (49)(30) 7053110

Cerrada Félix Cuevas #7-8
Col. Del Valle 03100 México, D.F.
Tel/Fax (52)(5) 5590492

PALE OPAQUE SCREEN TINTS

Client *Mexico Tours (tourist agency in Germany)*
Design *Zappata Designers*
Art Director/
Designer *Ibo Angulo*

For very pale colors, try using silkscreen inks. Because
they are opaque, silkscreen inks in even the palest
tints print fully saturated. The subtle contrast between
the pale color and the thickness of the ink film
creates a rich effect not possible with offset inks.

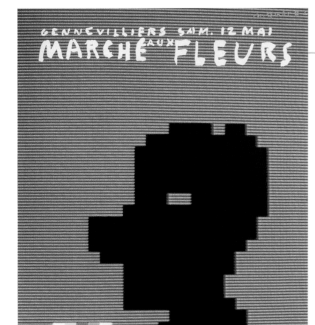

SILKSCREEN REGISTRATION

Client *Flower market in Gennevilliers, France*
Design *Michel Quarez*

Silkscreen inks on white paper look especially dense and saturated, as in this poster. As you can see, however, registration can be difficult. But the results might be worth the extra time and trouble.

FLEXOGRAPHIC INKS

Client | *UCLA Department of Architecture and Urban Design*
Design | *Reasonsense*
Designer | *Rebeca Méndez*
Assistant Designer | *Bryan Rackleff*

Flexographic inks can print on practically anything, even the garbage bags used for this poster. When used on paper, they are highly saturated, opaque, and a little hard to register. Each flexo press has to be individually fingerprinted, so check with your printer before spending a lot of time trapping inks on your desktop. Eighty percent of all desktop designs must be reconfigured by flexographic printers.

DENSE FLEXOGRAPHIC INKS

Client	*Planet Hollywood International*
Design	*Marvel*
Art Director/	
Designer	*Tracy Lesch*
Illustrator	*Marvel*

Here is another example of the quality that flexography is capable of these days. The color saturation of flexographic inks, coupled with a high-gloss, clay-coat substrate and topped with UV high-gloss varnish, creates a package that glows almost on its own.

DIGITAL INKS

Client · *Gillian and Todd Heintz*
Design · *Cappelletto Design Group*
Art Director · *Ivana Cappelletto*
Designers · *Antonia Banyard, Ivana Cappelletto*

Digital inks—really more like toners—are crisper than offset inks. So even pastels look a bit harsh.
On the other hand, digital presses, ability to print high-quality, short-run color jobs (in this case 178 wedding invitations) may outweigh the design disadvantages. And if you know ahead of time how your printing equipment translates designs onto paper, you can turn any disadvantages into design strengths. Digital printing is totally consistent every time, with no in-line color conflicts.

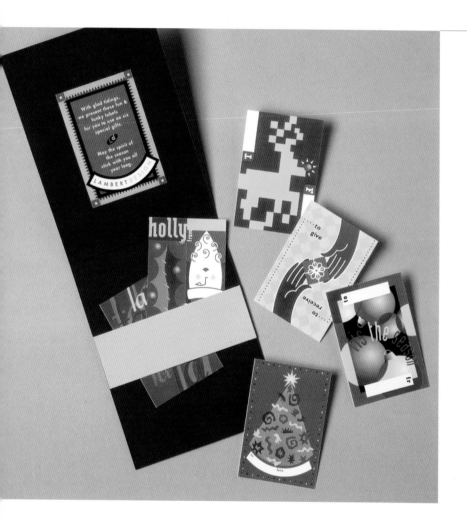

DIGITAL SENSE

Client/Design *Lambert Design*
Art Director *Christie Lambert*
Designer *Joy Cathy Price*

This example of digitized printing, done on an Indigo press, included nine separate colorful stickers. At a press run of only 100 copies, high-quality, four-color work is economical only in the digital world. Toners replace traditional inks and electronic commands replace plates, so makeready is essentially the same operation as prepress. The drawback? The system is slow and still fairly expensive, which is why most digitized print runs are short.

WAX-FREE INKS

Client	*Goodwin Tucker Group*
Design	*Sayles Graphic Design*
Art Director/	
Illustrator	*John Sayles*
Designers	*John Sayles, Jennifer Elliott*

When printing letterhead that will be used in a laser
printer later, make sure to specify wax-free inks. Laser
printers use heat to set the toner, which can wreak
havoc on inks made with wax.

ENGRAVING INKS

Client | *Otis Elevator*
Design | *Decker*
Client Contact | *Peter Kowalchuk*
Strategic Director | *Andrew Maguire*
Creative Director/
Copywriter | *Jay Durepo*
Senior Art Director | *Gloria Priam*

For really fine-line printing, check out engraving. Engraving involves etching a metal plate, filling the recesses with opaque ink, and pressing paper into the recesses to print an image. Because the metal edges of the plate keep paper from spreading, there is almost no dot gain. In this example, the designer used real postage stamps engraved 40 years ago by the U.S. Postal Service to create a lost-letter effect. Look at the fine detail in the stamp.

DESIGN FLEXIBILITY

Client/Design | *Mireille Smits Design*
Designer/Illustrator | *Mireille Smits*

Line-art designs with no halftone dots allow great flexibility in choice of inks and printing processes. In this case, the job was photocopied onto off-the-shelf specialty paper. Using the same setup, this design could be scanned into a desktop system and laser-printed on precut specialty papers too. Or it could be printed conventionally on a sheetfed offset press. Or digitally on a digital press. Or silkscreened on T-shirts. Or even printed flexographically on metal.

SOY-BASED INKS

Client	*Found Stuff Paper Works*
Design	*Mires Design*
Art Director	*José A. Serrano*
Designers	*José A. Serrano, Miguel Perez*
Illustrator	*Tracy Sabin*

Soy-based inks have more color saturation than conventional, petroleum-based inks. They also produce more even ink coverage, so they are a good choice for rough-coated papers, as shown here. On the down side, they may require more drying time, so set-off (when the ink of one sheet rubs off on another) can be a problem. Make sure your printer is experienced with soy inks, and mention your concern about set-off ahead of time. Raising issues like this early in the process often makes them go away.

FLEXOGRAPHIC INK SATURATION

Client | *Steve Madden*
Design | *Hampel Stefanides*
Art Director/
Designer/Illustrator | *Tom Kane*

Although flexography cannot print details as fine as
offset printing, it is getting closer all the time. In this
example, the design was screened at 100 lines per
inch, which would be too coarse for most photographs
but works fine for flat colors. The advantage of
flexographic inks is that they are opaque and very
dense, so the colors are extremely saturated and can
be printed on almost any surface.

directory

About the Author

Constance Sidles is a print production consultant and print buyer with more than 25 years of experience producing books, magazines, catalogs, brochures and all the other examples of the printed word that so gloriously fill our mail slots every day. She began her career with a degree in Egyptology, a field in which the printed word was literally sacred and the people who commissioned the work were absolute rulers. So she felt well-qualified to begin her first job working as a production assistant for a monthly magazine, under the direction of a quirky editor and a highly creative designer.

Sixteen years ago, Sidles opened her own print production consulting business, specializing in trouble-shooting and writing. She is the "Tech Tips" editor of *HOW* magazine, a columnist for *Adobe* magazine, and a regular contributor to several other publications. Her most recent book is *Great Production by Design*, published by North Light Books.